M000199102

It's hard to put into words, but
it's easy to see why... the love
that is felt for a son like you
is one of the most
wonderful things
there could ever be.

ISBN: 978-1-68088-340-4

▉ and Blue Mountain Press are registered in U.S. Patent and Trademark Office.
Certain trademarks are used under license.

Printed in China.
Second Printing: 2021

✪ This book is printed on recycled paper.

This book is printed on paper that has been specially produced to be acid free (neutral pH) and contains no groundwood or unbleached pulp. It conforms with the requirements of the American National Standards Institute, Inc., so as to ensure that this book will last and be enjoyed by future generations.

Blue Mountain Arts, Inc.
P.O. Box 4549, Boulder, Colorado 80306

Son...

I Want You
to Remember This

Douglas Pagels

Blue Mountain Press™
Boulder, Colorado

Sometimes we need reminders
in our lives of how much we're loved.

If you ever get that feeling, I want you
to remember this...

I dearly love you, Son. Beyond words that can even tell you how much, I hold you and your happiness within my heart each and every day.

I am so proud of you and so thankful to the years that have given me so much to be thankful for. And I want you to know, if I were given a chance to be anything I wanted to become, there is nothing I'd rather be than your parent.

And there is no one I'd rather have...
as my son.

Everywhere you go in life, my love will be by your side. And these wishes will be too.

I hope that the world will treat you fairly. That people will appreciate the one-in-a-million person you are. That you will be safe and smart and sure to make good choices on your journey through life.

That a wealth of opportunities will come your way. That your blessings will be many, your troubles will be few, and that life will be very generous in giving you all the happiness and success you deserve...

You are the joy of my life and the best present life could ever give to anyone. I hope you'll remember that, even after this book is read and set aside.

I'll always love you, Son, with all my heart.

And I couldn't be more proud of you...
if I tried.

Sometimes when we're together, I just have to stop whatever I'm doing and look over at you and grin… and simply let the feeling soak in of how lucky I am to be the parent of such a terrific son.

Even if you were halfway around the world, you would never be far from my heart. You can bring me happiness from wherever you are, and I know that's true... because you do it every day.

One of the most wonderful things that
could ever happen to anyone…
happened to me.

I was blessed with you… as my son.

You have so many qualities that just shine inside you. Your heart is so big and you're so good at sharing smiles wherever you go.

You can make my whole day just by saying something that only you could say... in that very caring, completely natural, sometimes serious, often funny, and always precious way.

It is such a joy to have you so thankfully in my days and so dearly in my heart.

There are probably far too many things in my life that I take for granted. But you will never, ever be one of them. I know how blessed I am to have you here. In every way.

I am proud of you to the nth degree, and I can't help thinking of what complete and absolute joy I would have missed... if I hadn't had the gift... of you in my life.

I want you to be blessed with all these things...

I wish you beautiful sunrises. Positive thoughts. A joyful heart. A cheerful start that opens the door each day... to every good thing that wants to come your way.

Hopes that will never leave you. Dreams that will keep coming true. Health and happiness. Well-chosen paths. Friends to walk the way with. And love that loves you... right back.

Smiles you find in places
you never imagined they might be.

And endless thanks for all the smiles…
you always give to me.

I will always be filled with gratitude...
for so many things about you, Son.

It just comes so naturally to you to
share your goodness and kindness with
everyone around you. I think you were
born with a smile in your heart, and it's
one you'll never be without.

Whenever my heart is overflowing with pleasant thoughts and hopeful feelings, I always know it's because I've been thinking of you. And I just want you to know...

One of the things I love most about my life... is having you in it.

I want you to
promise me that you'll remember this...

no one's happiness is more important
to me than yours is.

There are days when my whole world revolves around you. There are times when I know things are going well for you, and when that happens, it seems like I smile myself to sleep.

There are moments when life has been unfair to you, and my heart just breaks... knowing what you're going through.

I will be here to love you, to listen with my heart, to support your hopes and dreams, and to believe in you every day, through everything.

You deserve to have so many great things come your way. One of my favorite things about being your parent is knowing — truly seeing and experiencing and appreciating — what an exceptional person you are.

I want you to see that person too. I want you to know that you are wise beyond your years and capable of reaching just about any goal you set.

And when it comes to a positive, purposeful life, one that brings so many good things to you, I want you to know how much you deserve it.

As I think back to the days gone by, one of the things I am most grateful for is that, although we're so far away from our earliest times together, we're still so close in our hearts… and we always will be. And I wouldn't trade the memories we've made… for anything.

Nothing was more fun or more rewarding than introducing you to the world (and the world to you) and watching your life unfold.

I remember thinking at least a million times what a joy you are to me...

and wondering how anyone could love someone... as much as I love you.

We ran outside to capture sunsets before they slipped away, and we strolled back in to share dinners and talks and the most precious times my world had ever known.

We turned our home into a place where love was and will always be... a constant part of our lives.

You are someone who has so many adventures ahead of you, opportunities to explore, and stars to keep on reaching for.

And as the years go by, my prayers and caring thoughts will travel beside you everywhere you go. My heart will be wishing you all the very best, and you will be more of a joy to me than you'll ever know.

The story of our family is a
beautiful blending...

of a thousand different things.

When you add up all the memories, the joys and the tears, the talks, the hugs, and the heartfelt feelings...

And then you weave in the smiles, the hopes, and our amazing journey together...

It's easy to see why the love in our family... is always and forever.

Ask me how important my family is to me and how essential my loved ones are, and I'll tell you this simple truth... nothing else even comes close.

The incredibly special connections we have with others are the things that matter most of all.

There is nothing more wonderful than telling the ones you cherish… how much they're loved and appreciated… every chance you get. There is no greater or more precious advice.

Love is what holds everything together. It's the ribbon around the gift of life.

All throughout my life, I have wished for the perfect words to tell you how proud I am of all you've done and everything you've become.

All throughout your life, you have amazed me and impressed me and given me countless reasons to love you more than I already do.

And I know that I could have hoped and dreamed all my life... and I could have wished on every star. But...

I couldn't have been blessed
with anyone more wonderful...

than the son that you are.

Everywhere you journey in life…

you will go with my love by your side.

And my understanding and support will always be close by.

I want you to be inspired to reach for all the things you want to do.

What's the right path for you? It's always going to be the one that... makes you smile, speaks to your heart, feels like the perfect fit, and fills you with hope for what lies ahead.

There's something wonderful you have helped me do. You have helped me discover how it feels to be endlessly grateful.

Thank you for all the times we've had, all the paths we've taken, and all the special things we've done. Thank you, Son, for being the blessing that you are... to my heart, to my life, and to me.

I want you to remember my favorite wish for you.

Just keep on being the best gift of all... being special, incredible you... with the abundance of things you're doing right.

I wish you more happiness and love than you ever dreamed of... in all your days... and for all of your life.

I couldn't have asked for a more amazing or a more remarkable son... and I want to thank you for bringing so many smiles into my life. Thank you for being in all my most treasured memories, my highest hopes, and my most thankful prayers.

We never know how life will turn out... or what the years will bring. But I want you to know this: of all the things I could have been...

I will always be grateful beyond words…

that I get to be the parent of the
best son in the whole wide world.

I get to be yours.

About the Author

 Best-selling author and editor Douglas Pagels has inspired millions of readers with his insights and anthologies. His books have sold over 3.5 million copies, and he is one of the most quoted contemporary writers on social media and online today.

His writings have been translated into over a dozen languages due to their global appeal and inspiring outlook on life, and his audience has now increased even more — thanks to his very popular line of pix & pagels greeting cards, books, calendars, and gift items. Be sure to visit www.douglaspagels.com to find out more about the author and this wonderful, colorful, and one-of-a-kind collection.

If you have enjoyed this book, please spread the word. Giving it a positive recommendation online is greatly appreciated! And be sure to keep this book close in the months and years to come. It will always be good to visit again, and it will bring you smiles and warm your heart every time you do.